LEONARDO
DRAWINGS

60 Works by
Leonardo da Vinci

Dover Publications, Inc., New York

PUBLISHER'S NOTE

All the manifold interests of Leonardo da Vinci (1452–1519), "Renaissance man" par excellence, are reflected in his remarkable drawings. These drawings, which make supremely skillful use of a wide variety of media, constitute the chief surviving achievement of the great artist, so many of whose other works are lost or in ruinous condition.

The representative selection in this volume includes figure, drapery, landscape and compositional sketches for easel paintings, frescos and monumental sculptures; theatrical and allegorical designs; plans for civil and military engineering projects, some decidedly imaginative and "futuristic"; as well as anatomical, botanical, geological and other studies. They date from every part of the artist's career, which is generally divided into the first Florentine period (to 1481), the first Milanese period (1481–99), the second Florentine period (1500–05), the second Milanese period (1506–13), the Roman period (1513–16) and the French period (1516–19).

In view of the exceeding difficulty sometimes encountered in authenticating works by the great Renaissance masters, it is fortunate that the bulk of the extant Leonardo drawings—the *Codice Atlantico* in Milan, the notebooks in the Institut de France, and especially the numerous notebooks and independent drawings at Windsor Castle—have a clear ownership history that can be traced all the way back to the artist.

For the drawings in other collections, some of which are still disputed, authenticity can be established by comparison with Windsor Castle drawings or by association with several paintings and sculptures firmly attributed to Leonardo. These landmark works include the Uffizi painting *The Adoration of the Magi* (ca. 1481); the two versions (Louvre and National Gallery, London) of the painting *The Virgin of the Rocks* (ca. 1483); the never completed equestrian monument to Francesco Sforza, father of the tyrant of Milan (ca. 1490); the fresco *The Last Supper in Milan* (ca. 1497); the Louvre painting *Mona Lisa* (ca. 1500–05); the never completed Florentine fresco *The Battle of Anghiari* (ca. 1504); the never completed equestrian monument to Marshal Trivulzio and the National Gallery (London) painting *The Madonna with St. Anne* (both from the second Milanese period).

The identifications, authentications and datings in this volume represent the views of several recent reliable publications on Leonardo. It should be remembered that Leonardo scholarship is being actively pursued, and that there is always the possibility of new discoveries (Leonardo's exact birth date was not learned until 1939) which will necessitate revisions in current accounts of the artist's life and work.

Leonardo Drawings, first published by Dover Publications, Inc., in 1980, is a new selection of drawings reproduced from a variety of published sources. The captions and Publisher's Note have been prepared specially for the present edition.

International Standard Book Number: 0-486-23951-9
Library of Congress Catalog Card Number: 79-55673

Manufactured in the United States of America
Dover Publications, Inc.
31 East 2nd Street
Mineola, N.Y. 11501

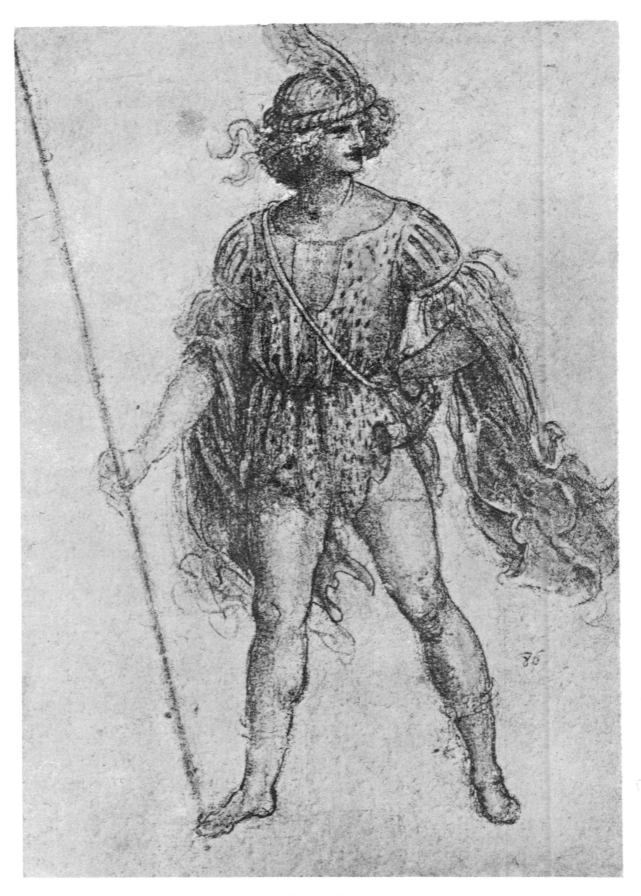

Youth with a lance; perhaps a costume for a Milanese court pageant, ca. 1490; it has also been dated after 1513. Black crayon, heightened with white. 275 x 185 mm. Royal Library, Windsor Castle.

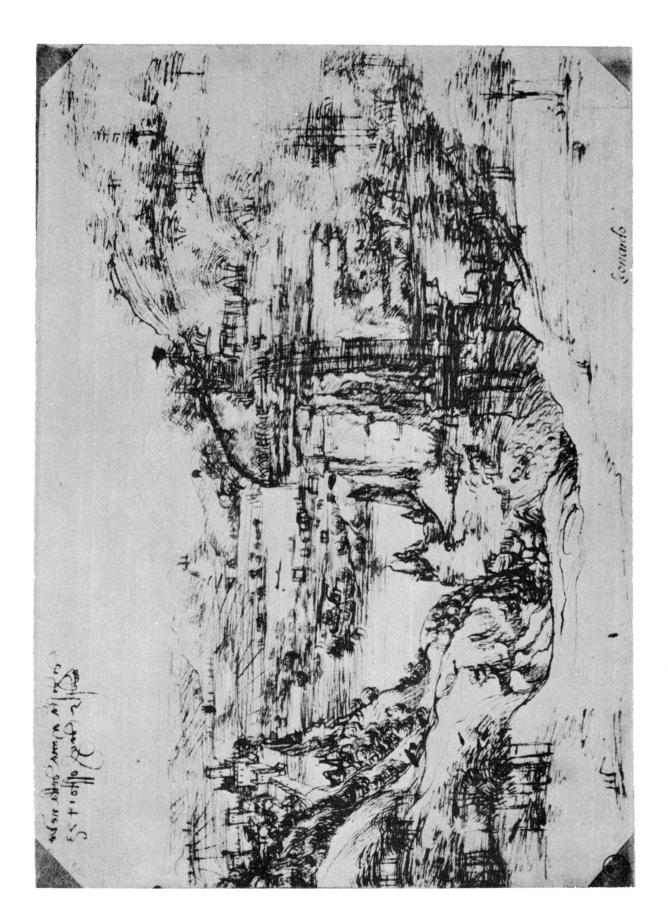

1. Landscape; inscribed: "of St. Mary of the Snow, August 5, 1473" (earliest dated Leonardo drawing). Pen. 195 x 285 mm. Florence, Uffizi.

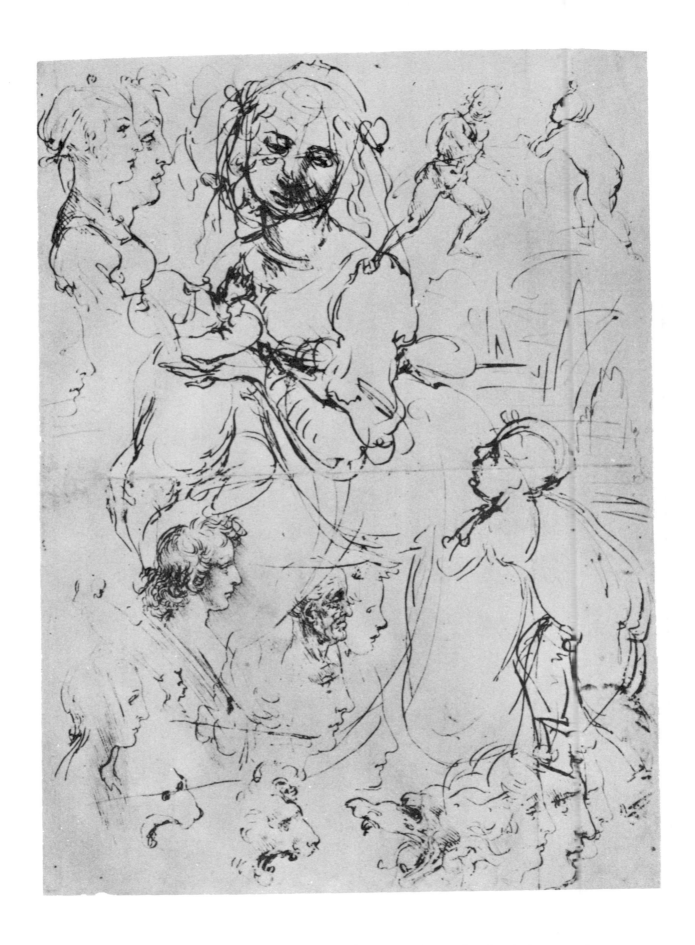

2. Studies of expressions in men, women, children and animals; sketch for a Madonna
with the Child St. John. Ca. 1475. Pen. Royal Library, Windsor Castle.

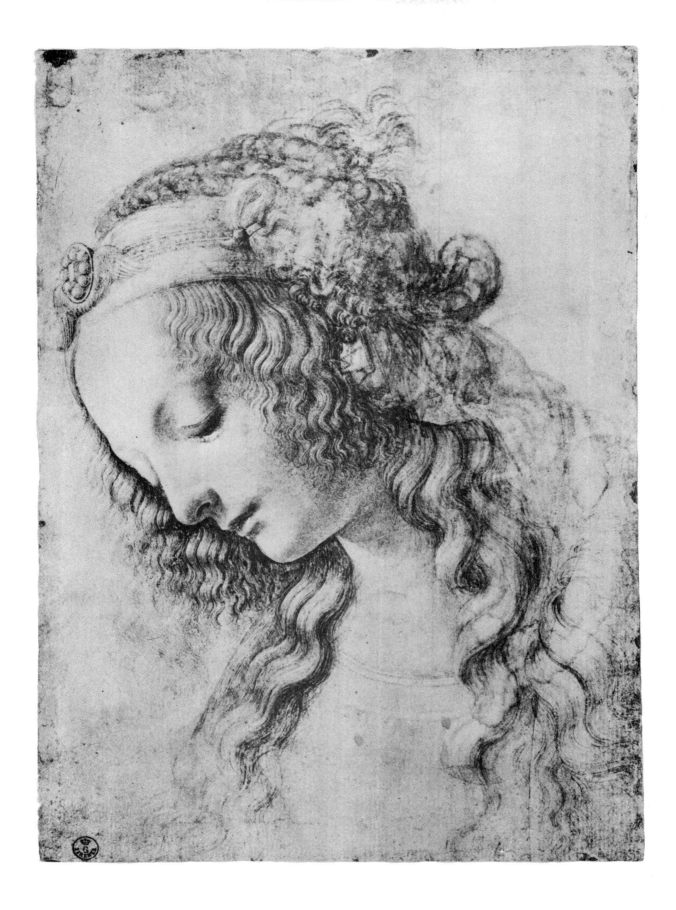

3. Profile of a young woman. Ca. 1475. Pen, heightened with white. Apparently a drawing for the Louvre *Annunciation* (although some scholars believe that Leonardo did neither the drawing nor the painting). Florence, Uffizi.

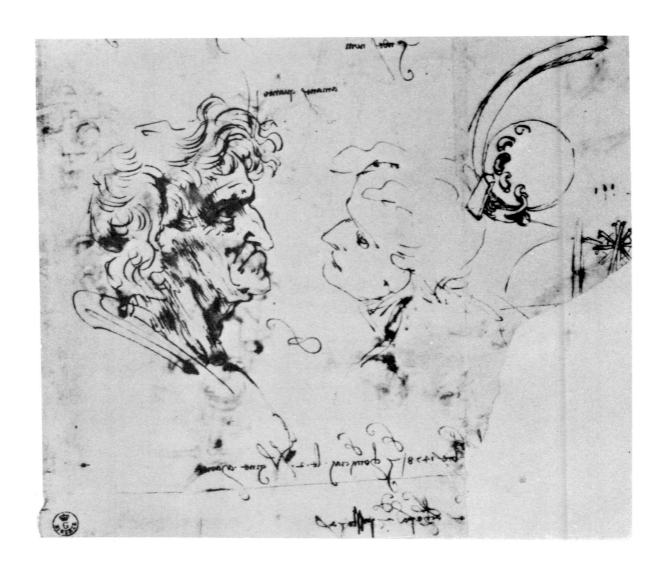

4. Head of an old man and profile of a youth. The inscription mentions a date late in 1478. Pen. Florence, Uffizi.

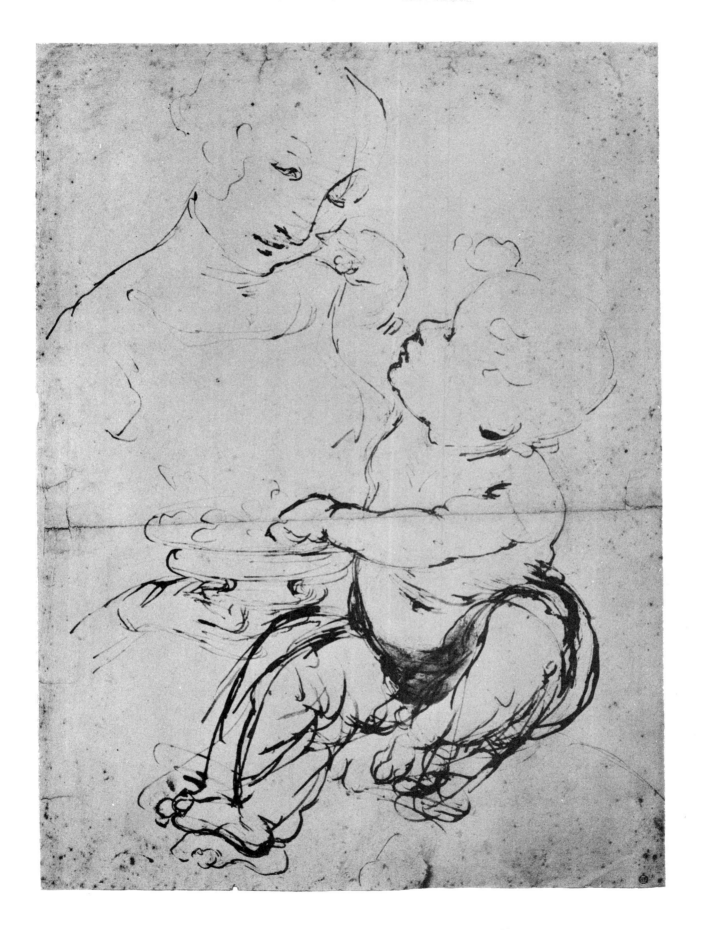

5. Madonna with a fruit dish. Ca. 1480. Silverpoint and pen. 350 x 250 mm. Paris, Louvre.

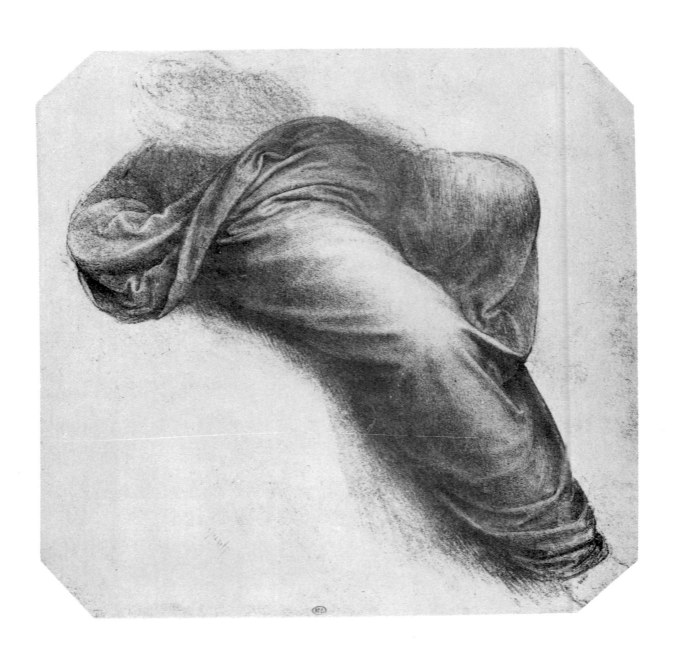

6. Study of drapery. Ca. 1480 (but it has also been associated with the later *Madonna with St. Anne*). Black crayon and bistre wash, heightened with white. 230 x 243 mm. Paris, Louvre.

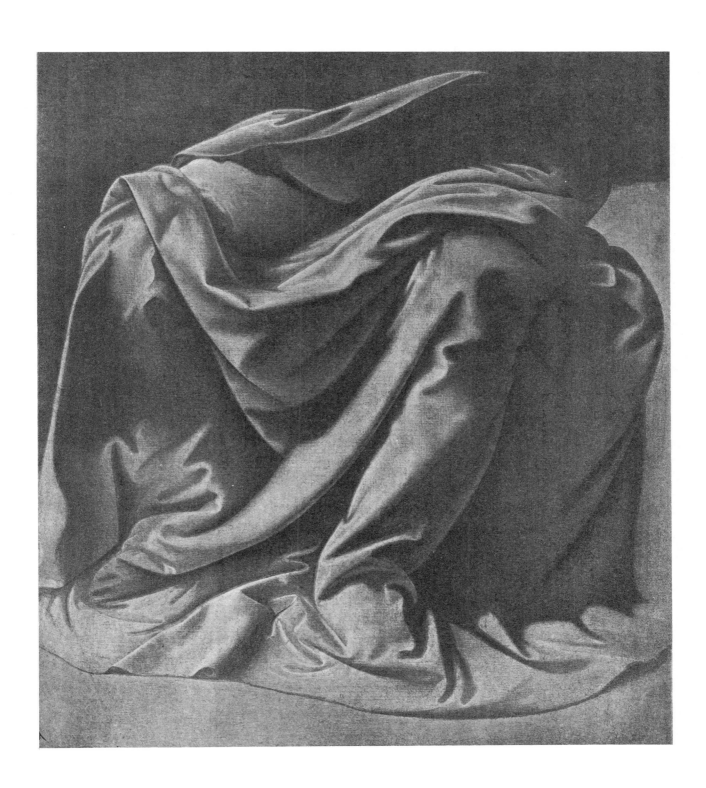

7. Study of drapery. Ca. 1480 (date disputed). Bistre, heightened with white, on canvas. 265 x 235 mm. Paris, Louvre.

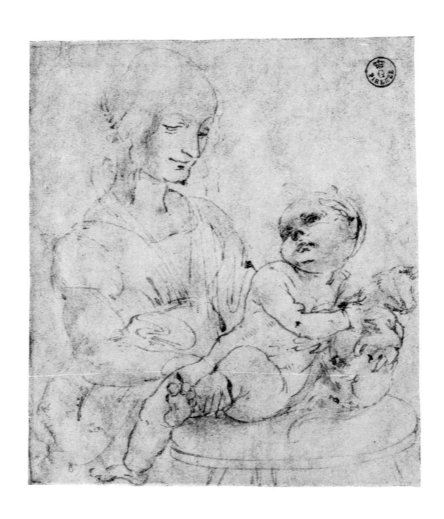

8. Sketch for a Madonna with Cat. Ca. 1480. Pen and wash. 125 x 105 mm. Florence, Uffizi.

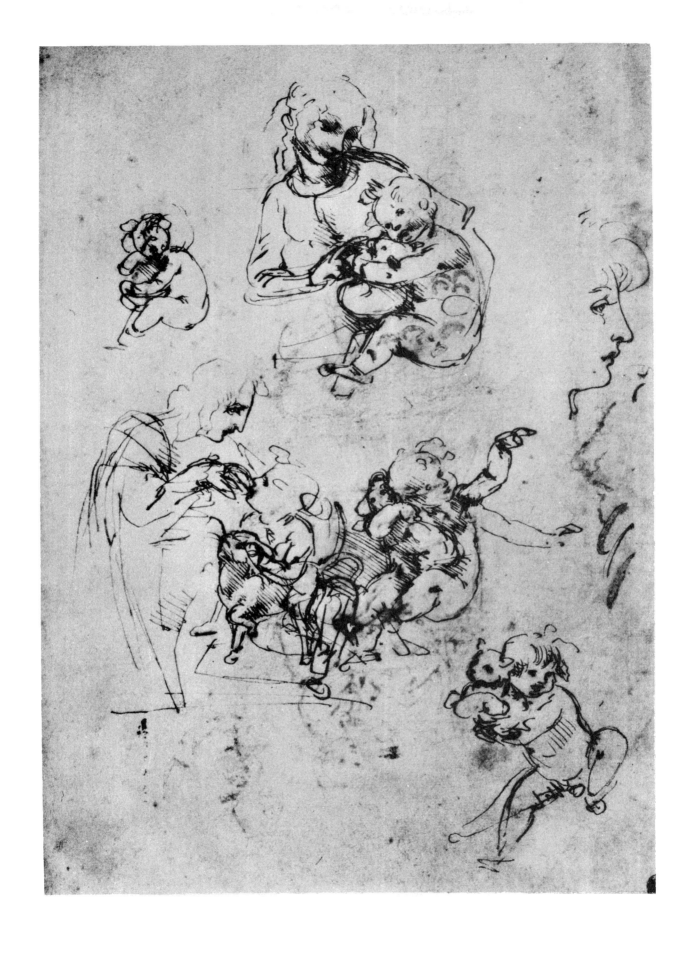

9. Studies for a Madonna with Cat. Ca. 1480. Pen. London, British Museum.

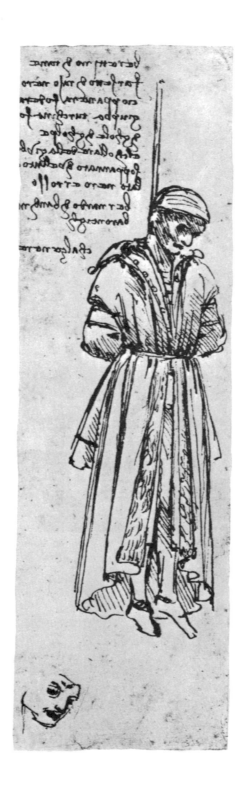

10. Hanged man; has been identified as Baroncelli, the assassin of Giuliano de' Medici (hanged 1478), and as Bernardo di Bandino (hanged 1479). Pen. 190 x 70 mm. Bayonne, Musée Bonnat.

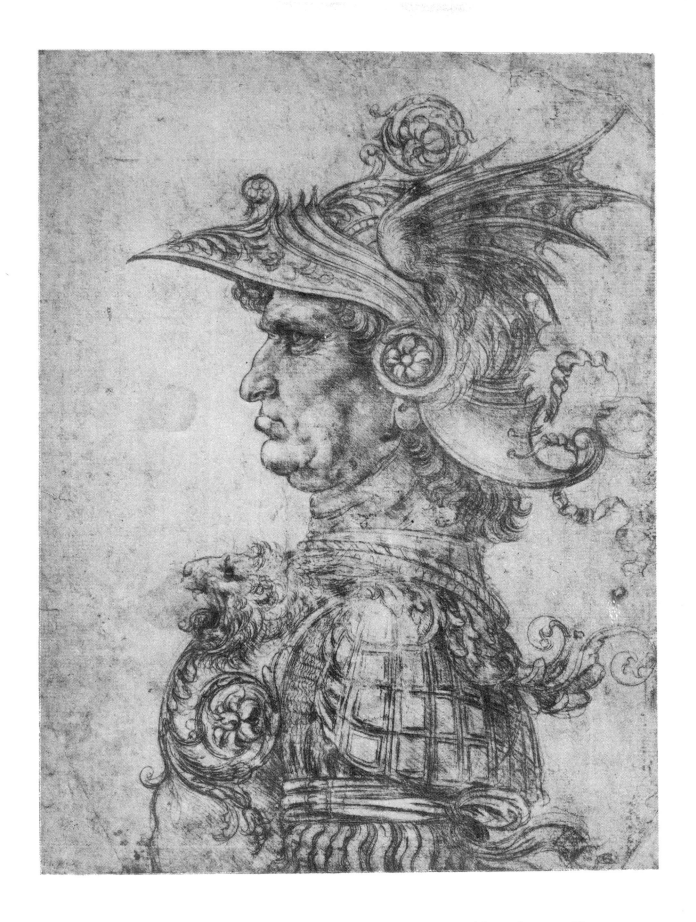

11. A condottiere in fanciful armor; said to have been suggested by a figure in Verrocchio's *Beheading of St. John the Baptist*. Ca. 1480. Silverpoint. 215 x 150 mm. London, British Museum.

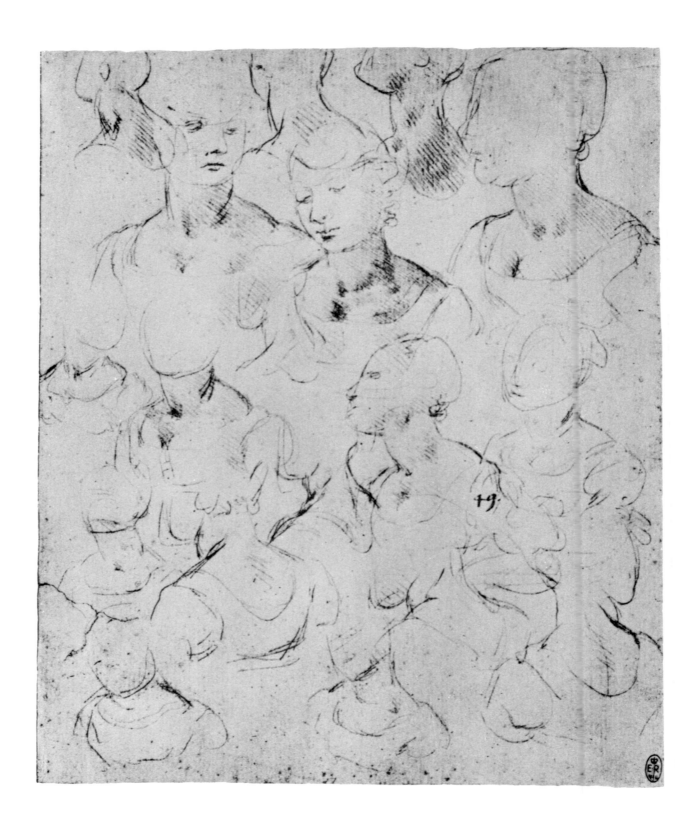

12. Shoulder-length studies of a woman. Ca. 1480. Silverpoint. Royal Library, Windsor Castle.

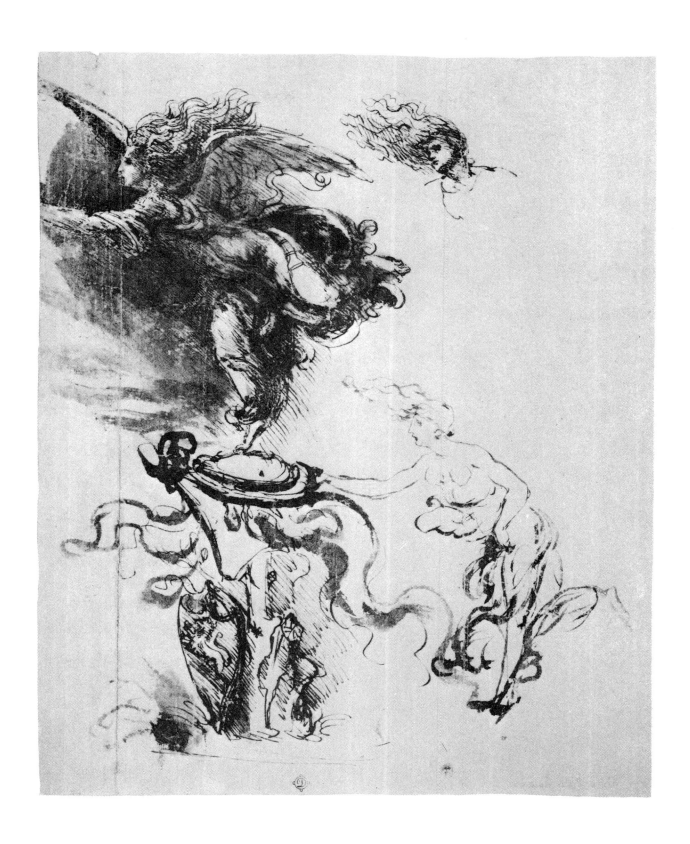

13. Female figure (Victory?) placing a shield on a trophy. Ca. 1480–81. Pen and brown wash over a stylus drawing. 255 x 205 mm. London, British Museum.

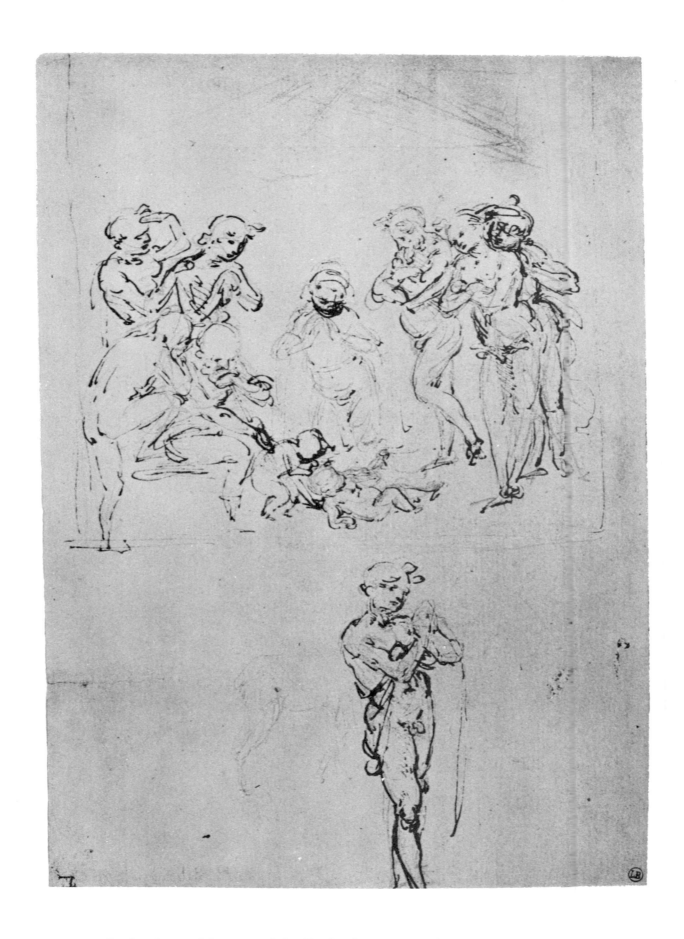

14. Studies for an Adoration of the Shepherds. Ca. 1480. Pen. 215 x 150 mm. Bayonne, Musée Bonnat.

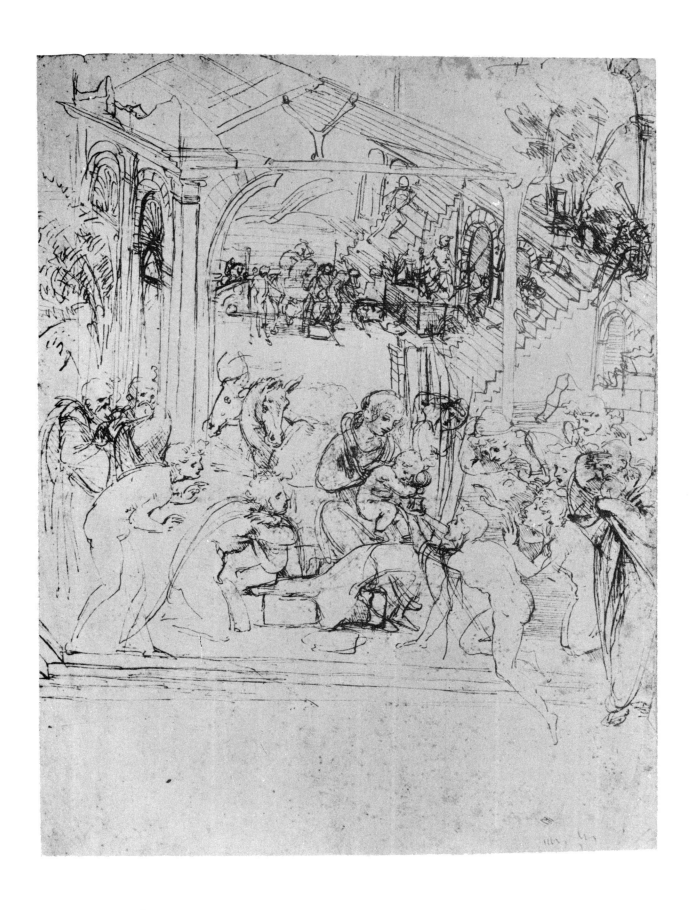

15. Full compositional study for *The Adoration of the Magi*. Ca. 1481. Pen. 280 x 210 mm. Paris, Louvre.

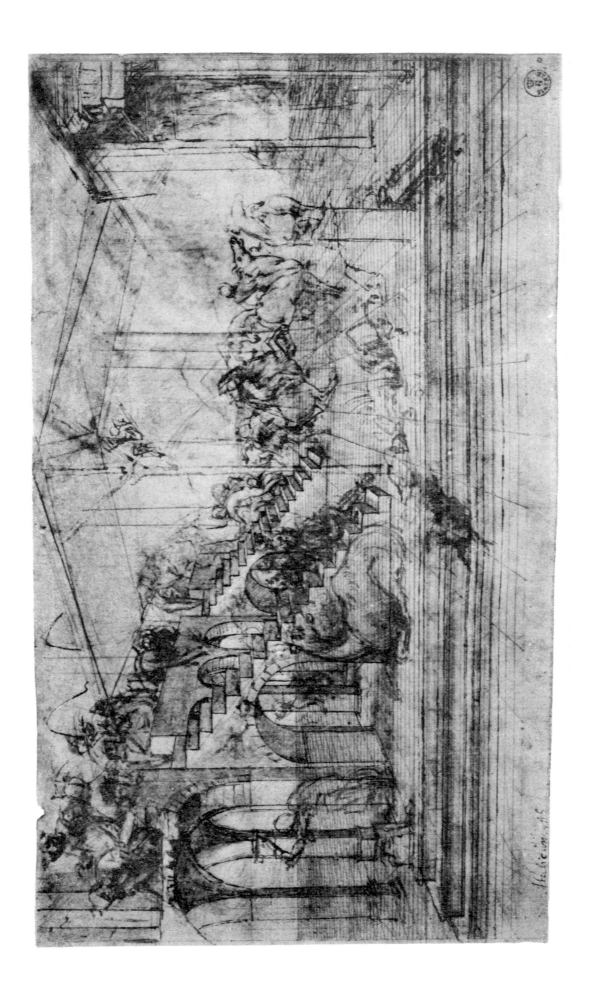

16. Study for the background of *The Adoration of the Magi*. Ca. 1481 Pen over metal point with wash. 165 x 290 mm. Florence. Uffizi.

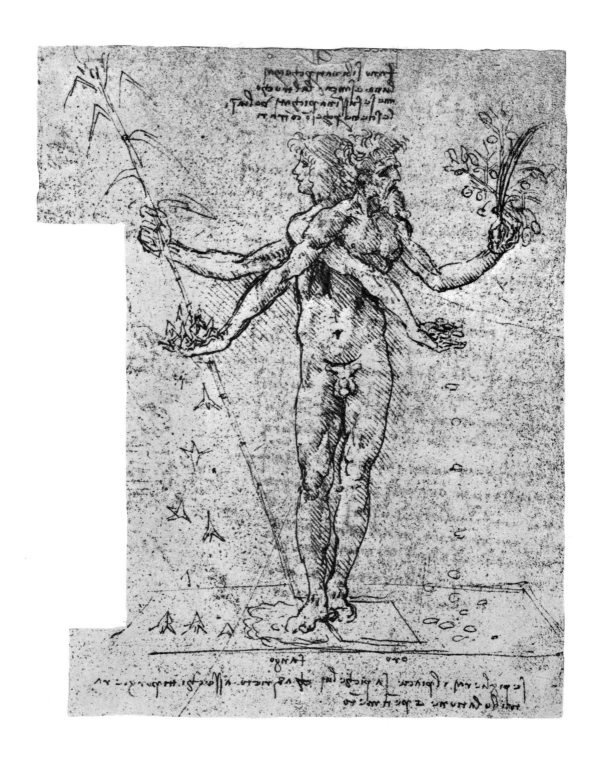

17. Pleasure and pain represented as twins. 1483–85. Pen. Oxford, Library of Christ Church College.

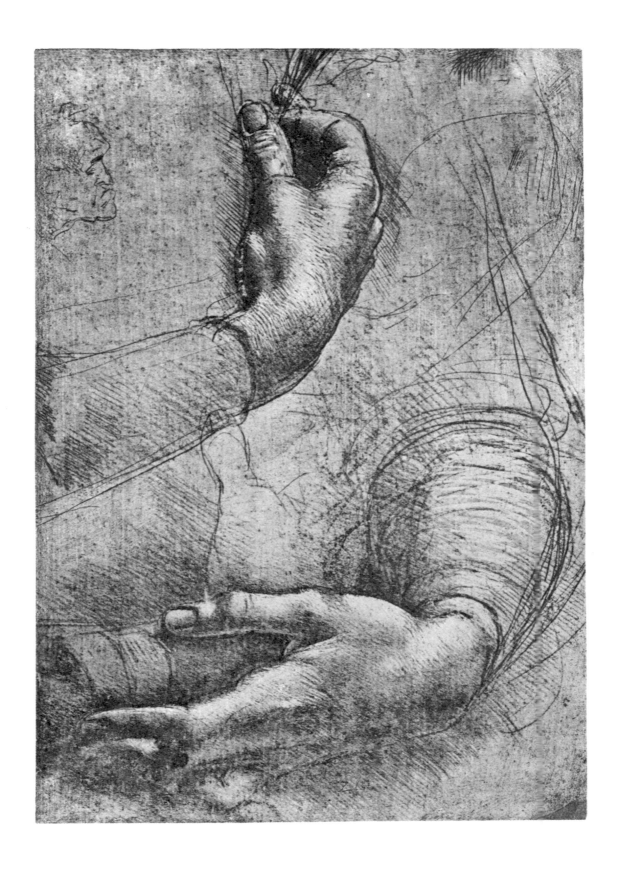

18. Study of hands; this has been associated with *The Virgin of the Rocks* and with the *Mona Lisa*. Before 1500. Silverpoint, heightened with white. Royal Library, Windsor Castle.

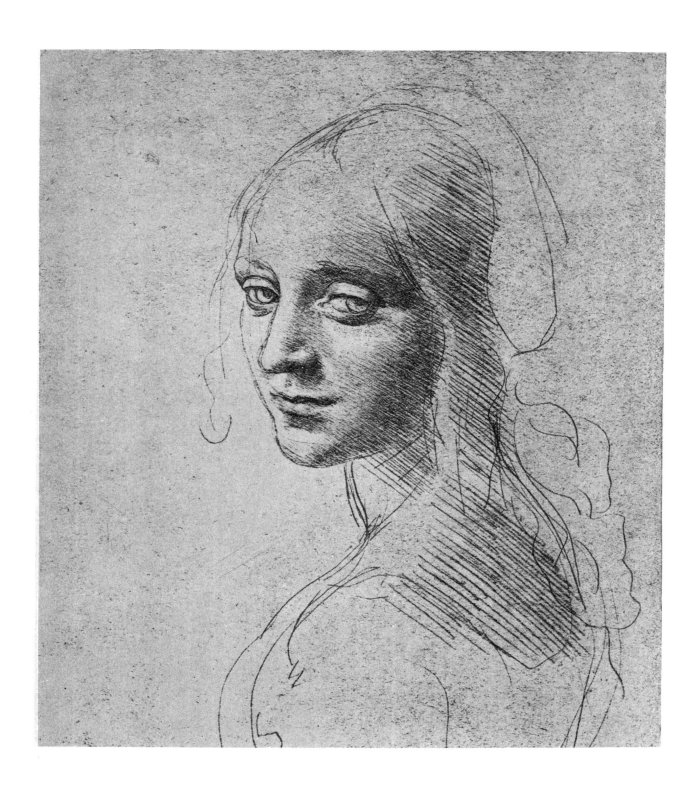

19. Study for the angel's head in *The Virgin of the Rocks*. 1483. Silverpoint. **Turin,** **Biblioteca Reale.**

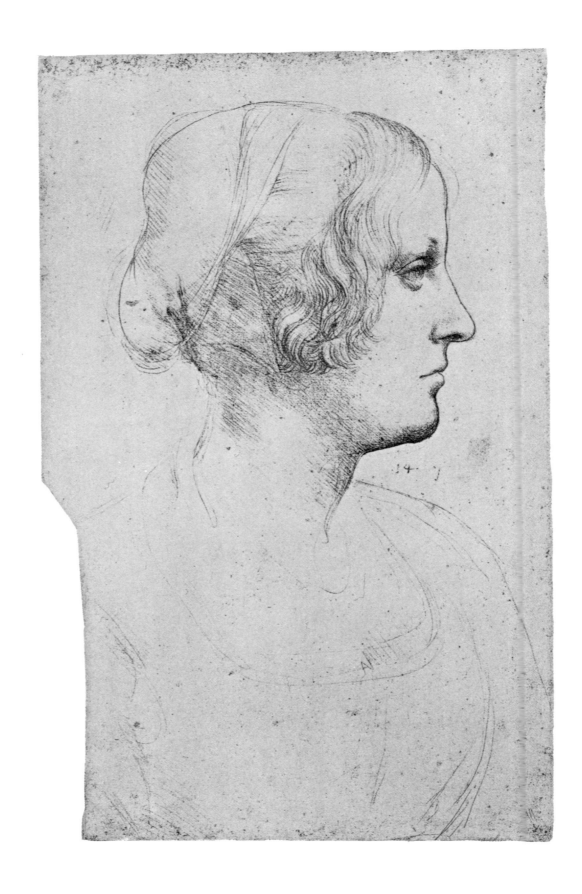

20. Profile of a woman. 1468–88. Silverpoint on a pale pinkish ground. 325 x 200 mm. Royal Library, Windsor Castle.

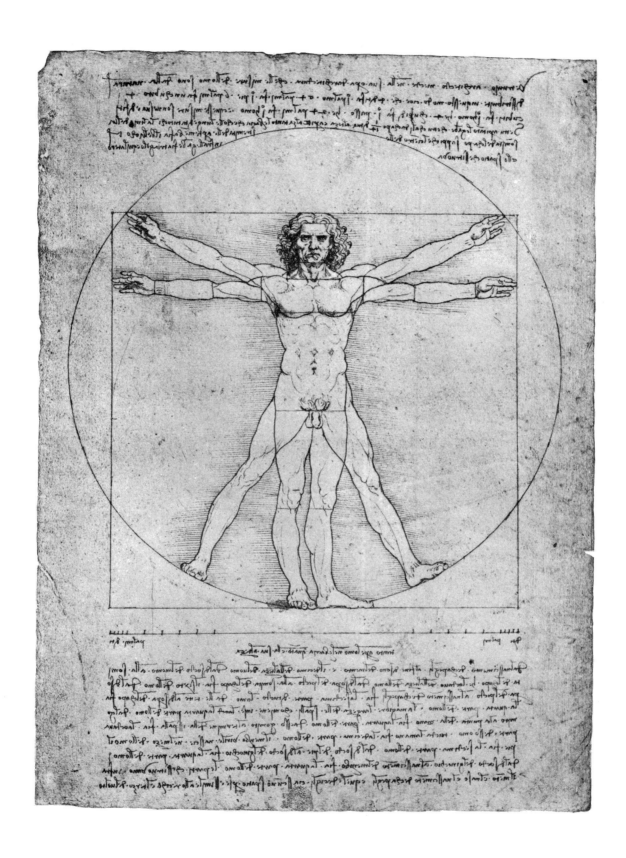

21. Diagram of human proportions. 1485–90. Pen. Venice, Accademia.

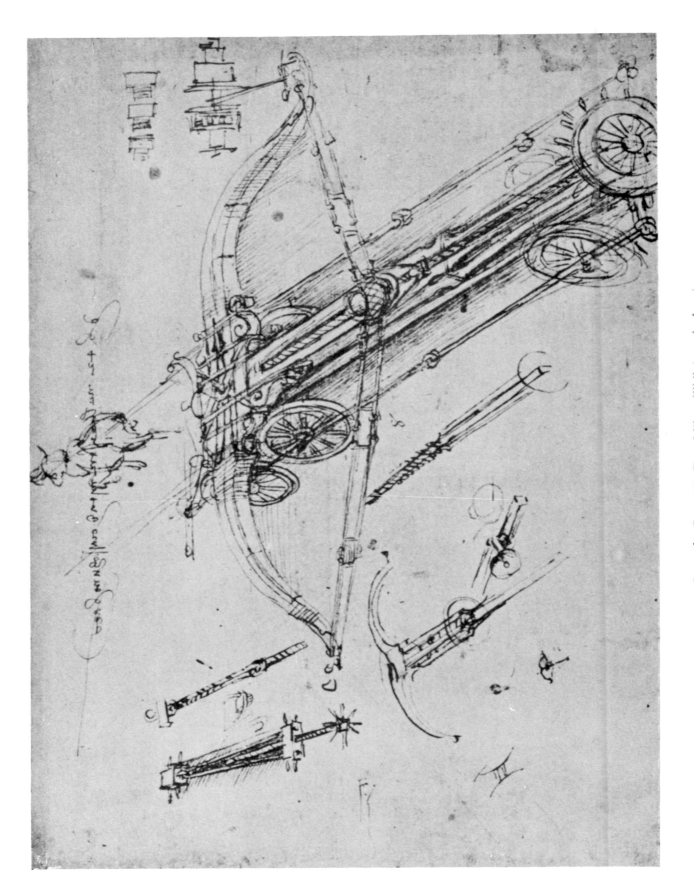

22. Catapult. Ca. 1490. Pen. Milan, Biblioteca Ambrosiana.

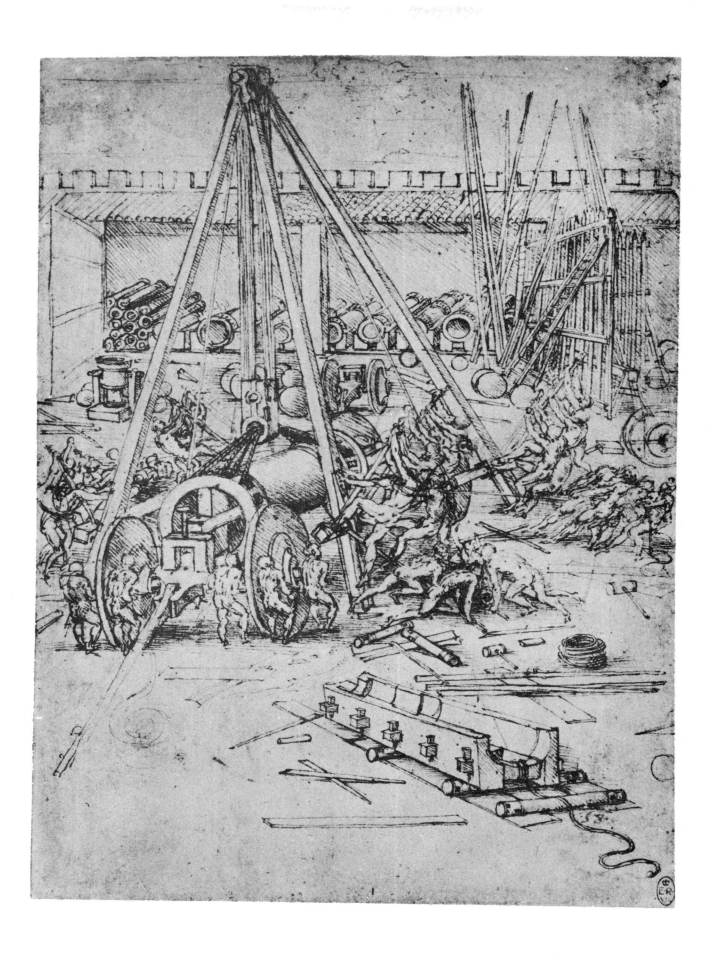

23. Cannon foundry. Ca. 1490. Pen. Royal Library, Windsor Castle.

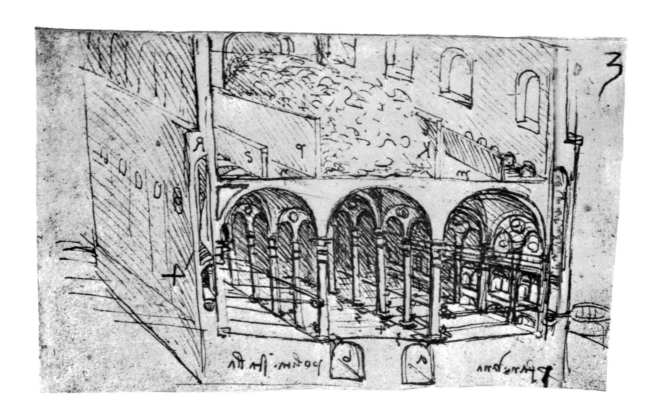

24. Design for a stable with automatic feed to the mangers. Ca. 1490. Pen. Paris, Institut de France.

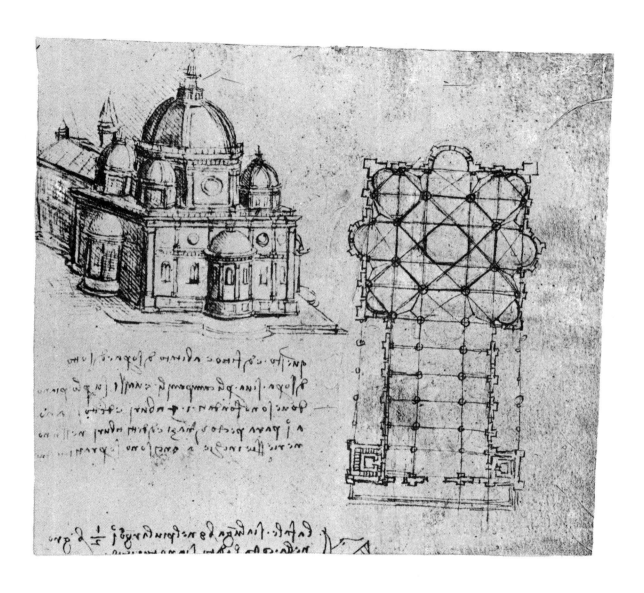

25. Ground plan and perspective view of a basilica with a many-domed tribune. Ca. 1490.
Pen. Paris, Institut de France.

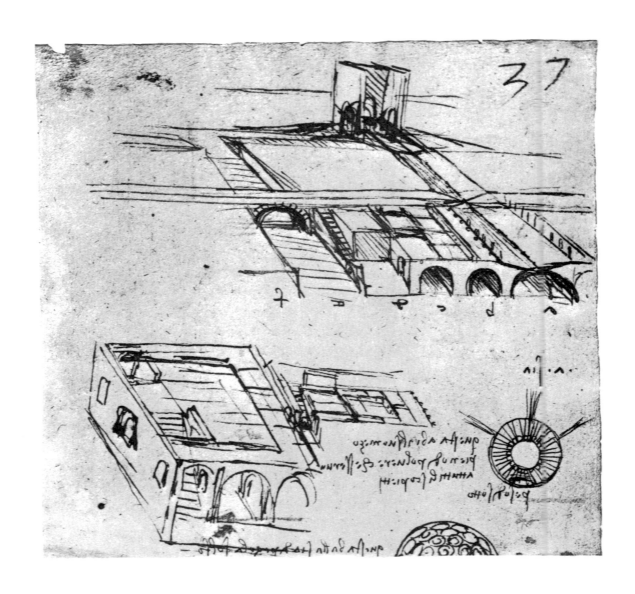

26. Water supply for a city with two levels of roadways. Ca. 1490. Pen. Paris, Institut de France.

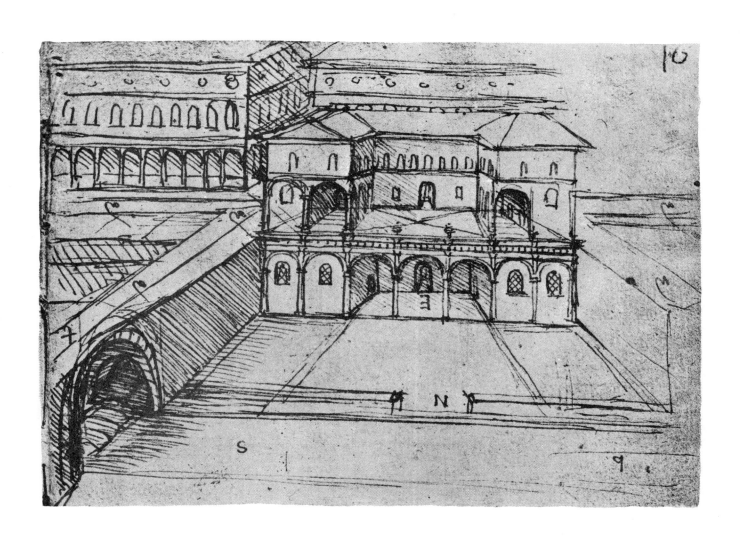

27. Partial view of a city with two levels of roadways. Ca. 1490. Pen. Paris, Institut de France.

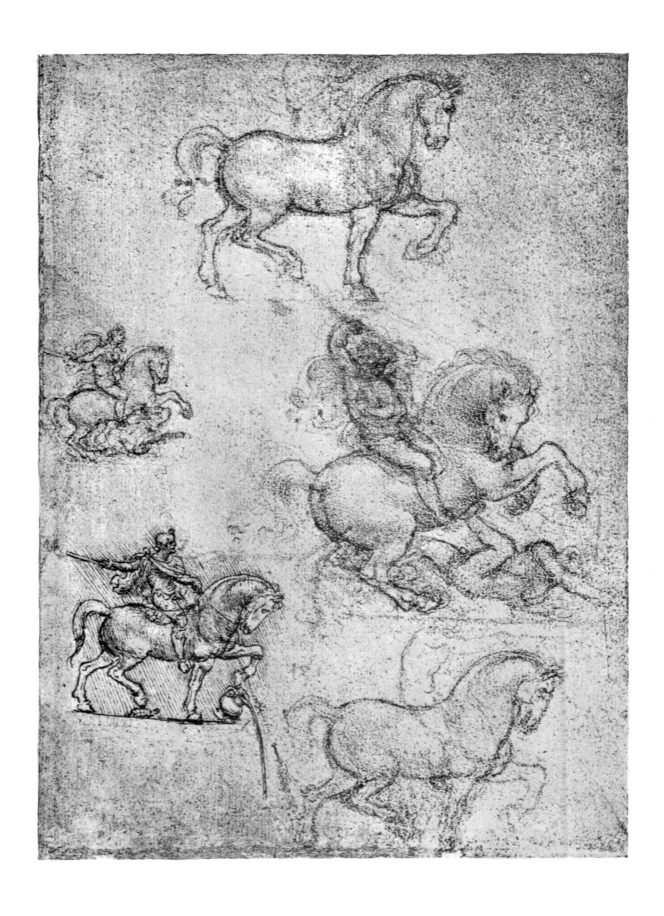

28. Studies for the monument to Francesco Sforza. Ca. 1490. Pen and black crayon. **220** x 160 mm. Royal Library, Windsor Castle.

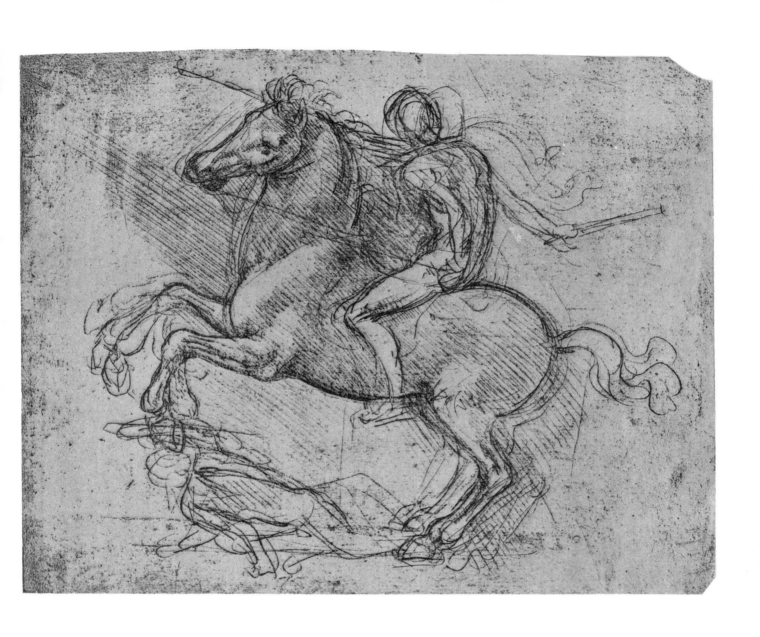

29. Study for the Sforza monument. Ca. 1490. Silverpoint on a blue-green ground. 150 x 185 mm. Royal Library, Windsor Castle.

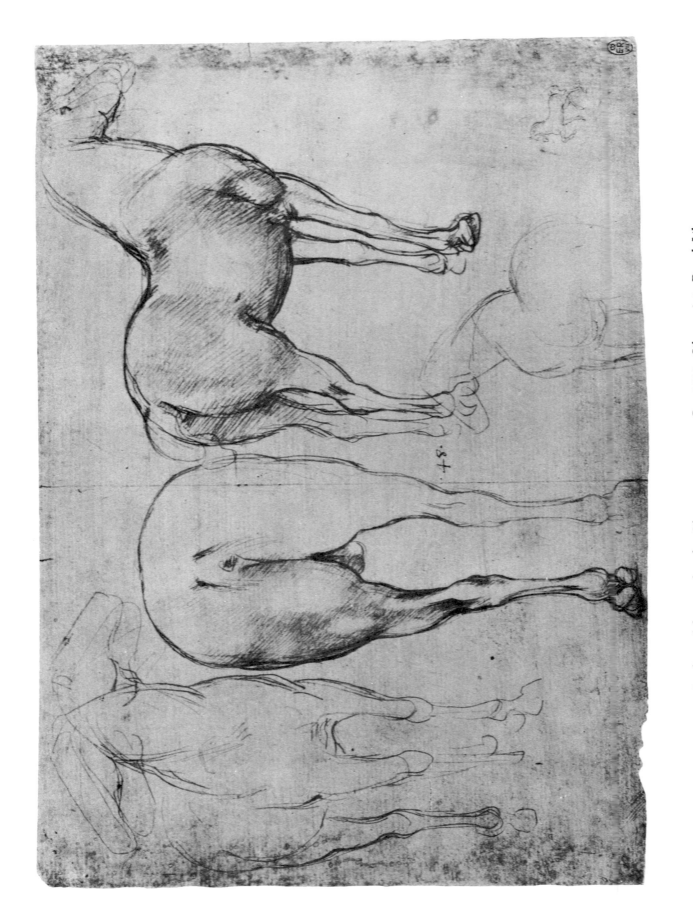

30. Studies of horses for the Sforza monument. Ca. 1490. Silverpoint. Royal Library, Windsor Castle.

31. Study for *The Last Supper*. Ca. 1497. Sanguine. Venice, Accademia.

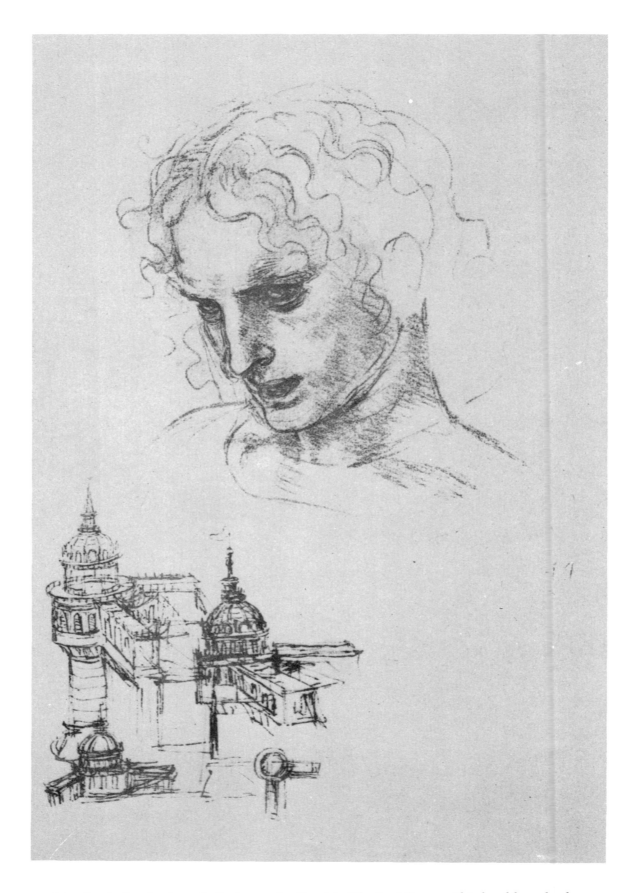

32. Study for the Apostle St. James the Great in *The Last Supper* (this head has also been associated with the later *Battle of Anghiari*), and a sketch of the pavilions on the towers of the Castello Sforzesco in Milan. Ca. 1497. Sanguine. 250 x 170 mm Royal Library, Windsor Castle.

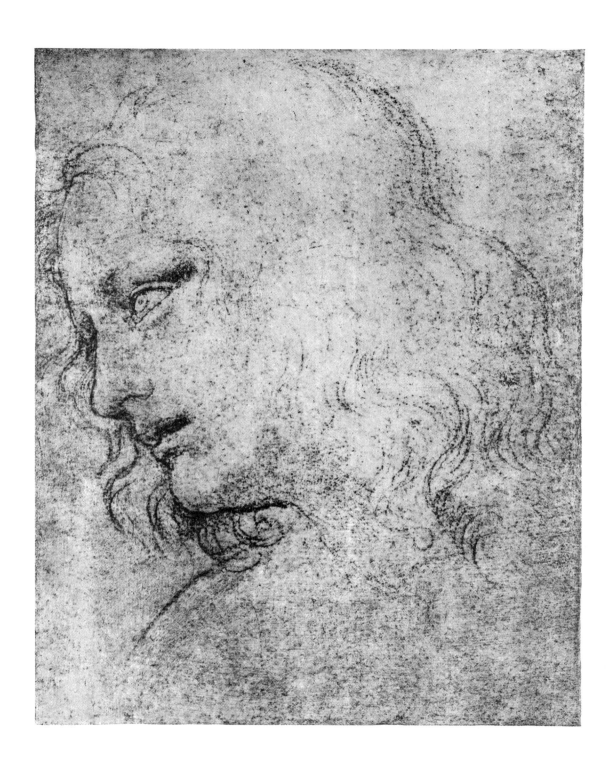

33. Study for the Apostle St. Philip in *The Last Supper*. Ca. 1497. Black crayon. 195 x 150 mm. Royal Library, Windsor Castle.

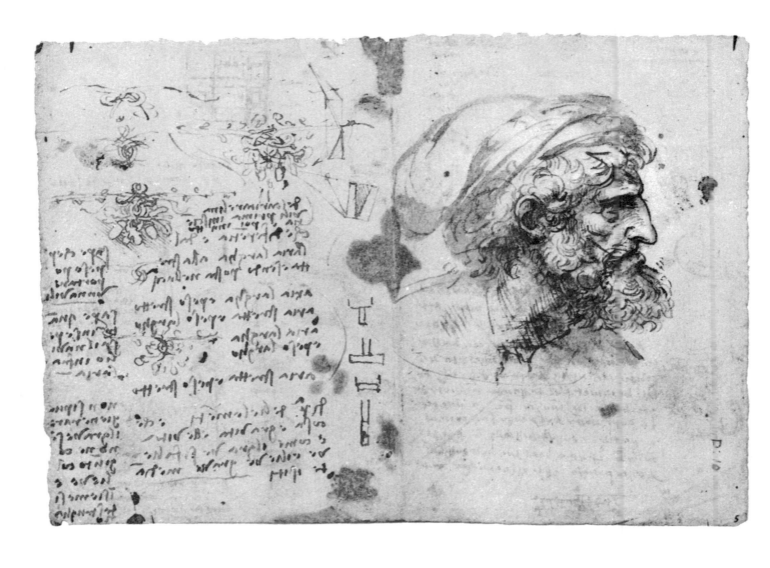

34. Man's profile and miscellaneous small figures. Ca. 1510. Pen, pencil and crayon. 145 x 205 mm. Royal Library, Windsor Castle.

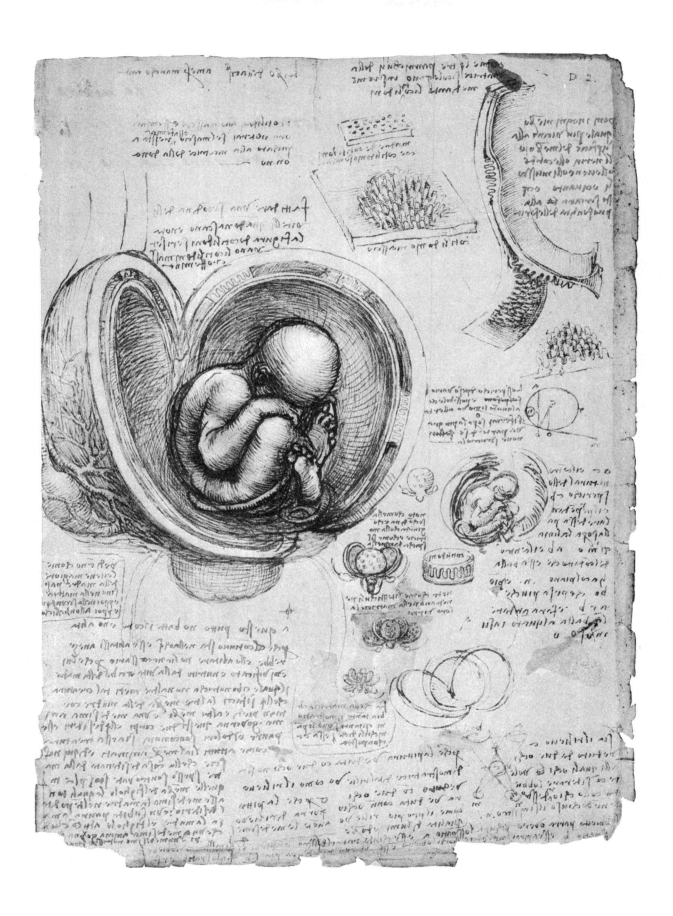

35. Study of uterus with embryo and membranes. Ca. 1510. Pen with crayon shading. 214
x 301 mm. Royal Library, Windsor Castle.

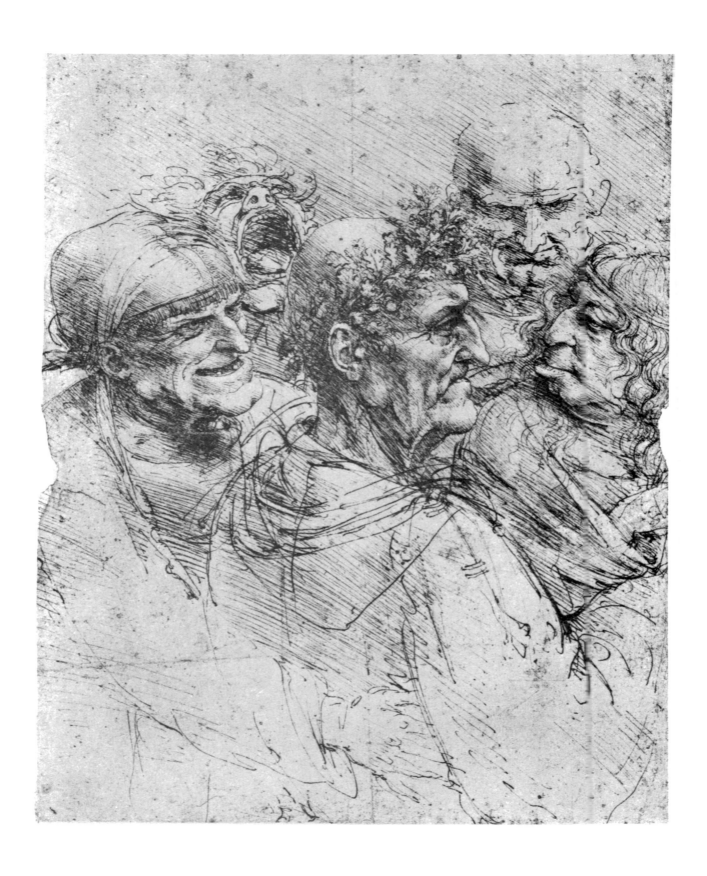

36. Old man with oak wreath and four grotesque figures. Late 1490s. Pen. Royal Library,
Windsor Castle.

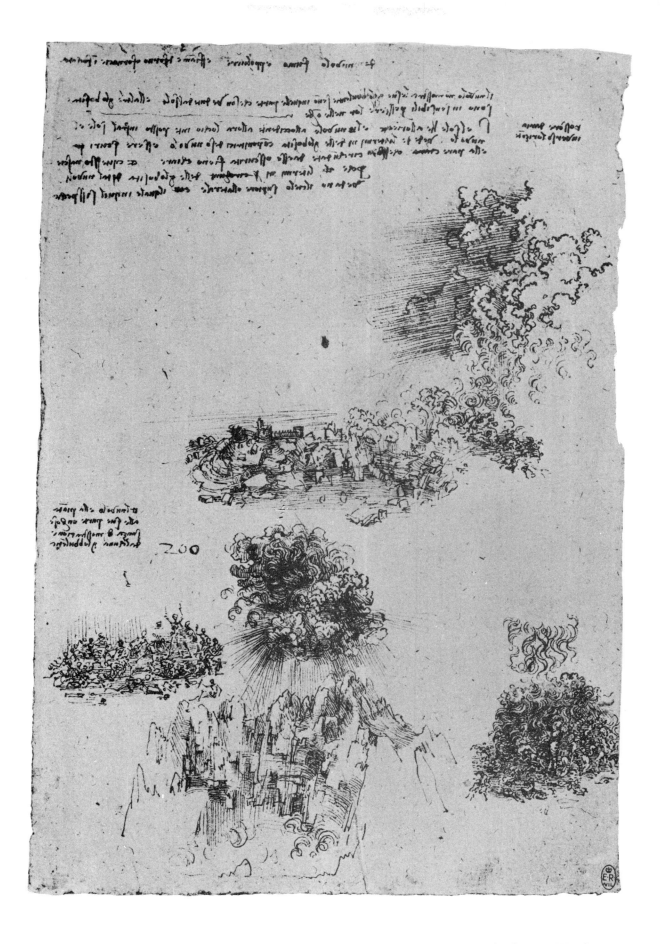

37. Studies of earthquake, rain of fire, resurrection. Ca. 1500. Pen. Royal Library, Windsor Castle.

38. Poplar or birch grove. Ca. 1500. Sanguine. Royal Library, Windsor Castle.

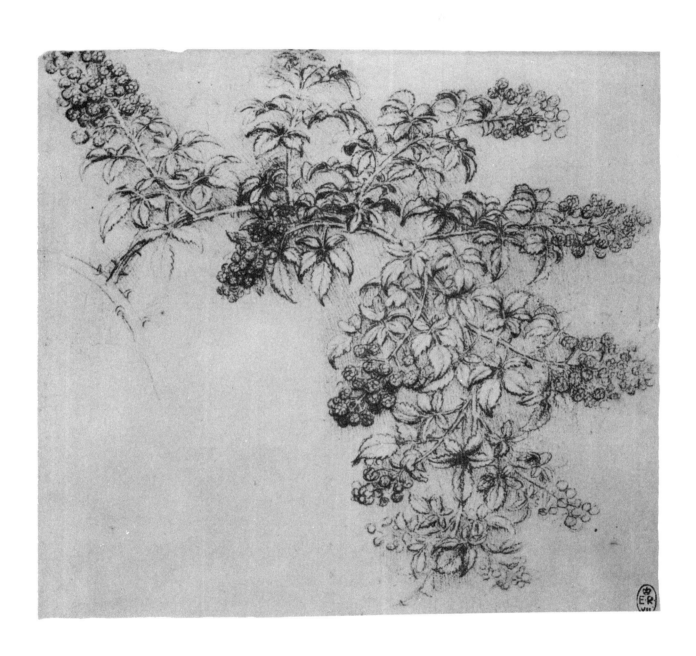

39. Raspberry (or related plant). Ca. 1500. Sanguine. Royal Library, Windsor Castle.

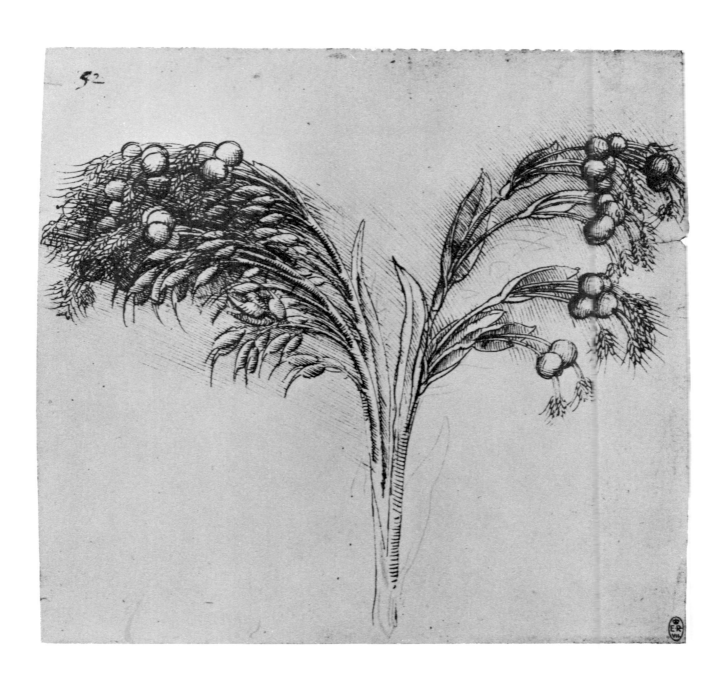

40.　Coix, or Job's-tears. Ca. 1500. Pen. Royal Library, Windsor Castle.

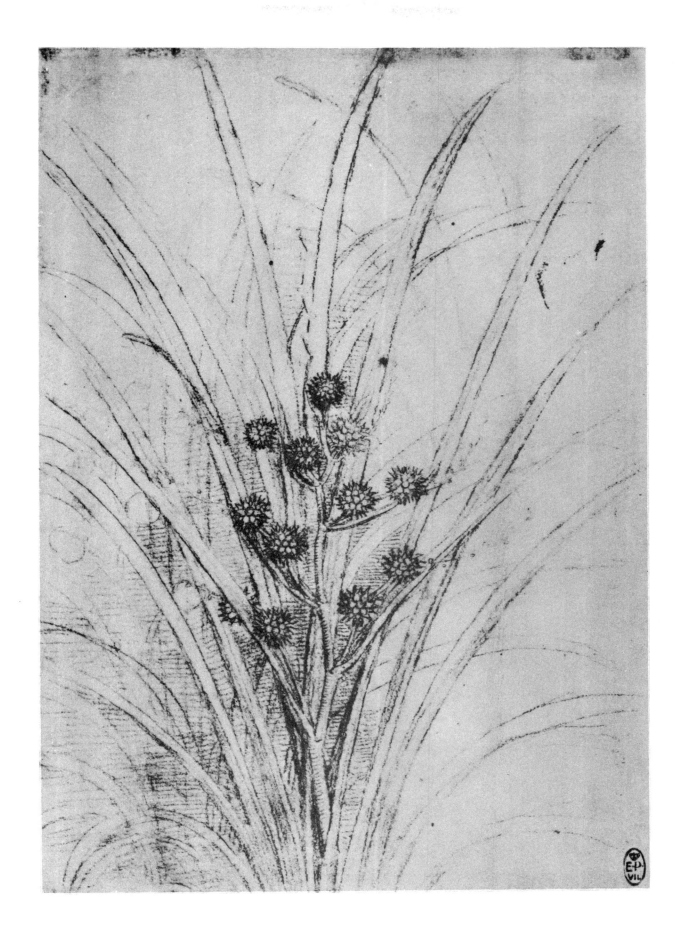

41. Sparganium, or bur reed. Ca. 1500. Sanguine. Royal Library, Windsor Castle.

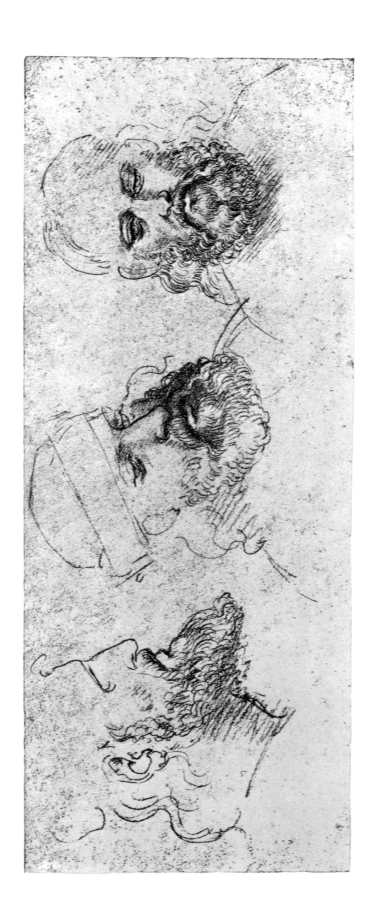

42. Heads (studies of Cesare Borgia?). 1502. Sanguine. Turin, Biblioteca Reale.

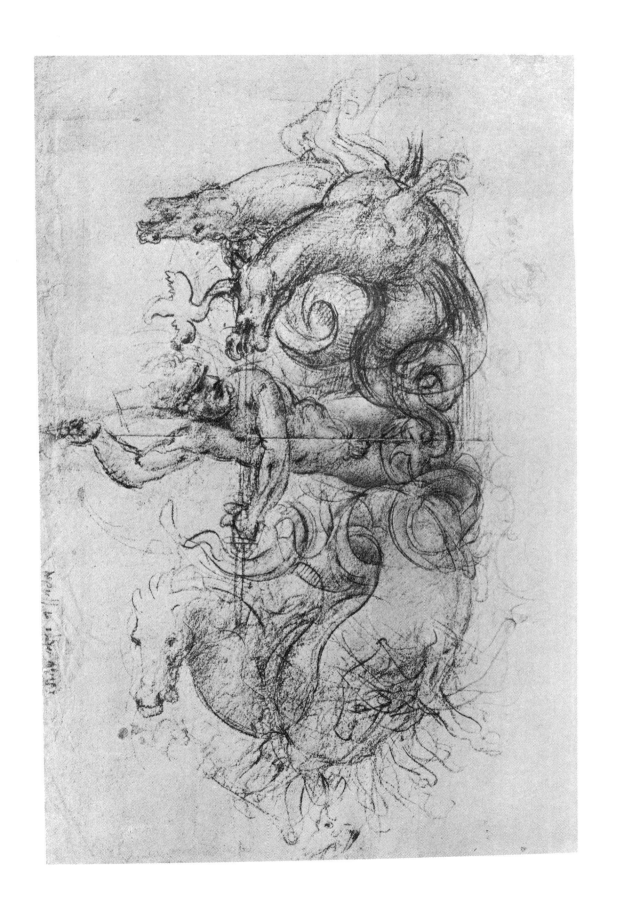

43. Neptune guiding his seahorses. 1503–04. Black chalk. 260 × 390 mm. Royal Library, Windsor Castle.

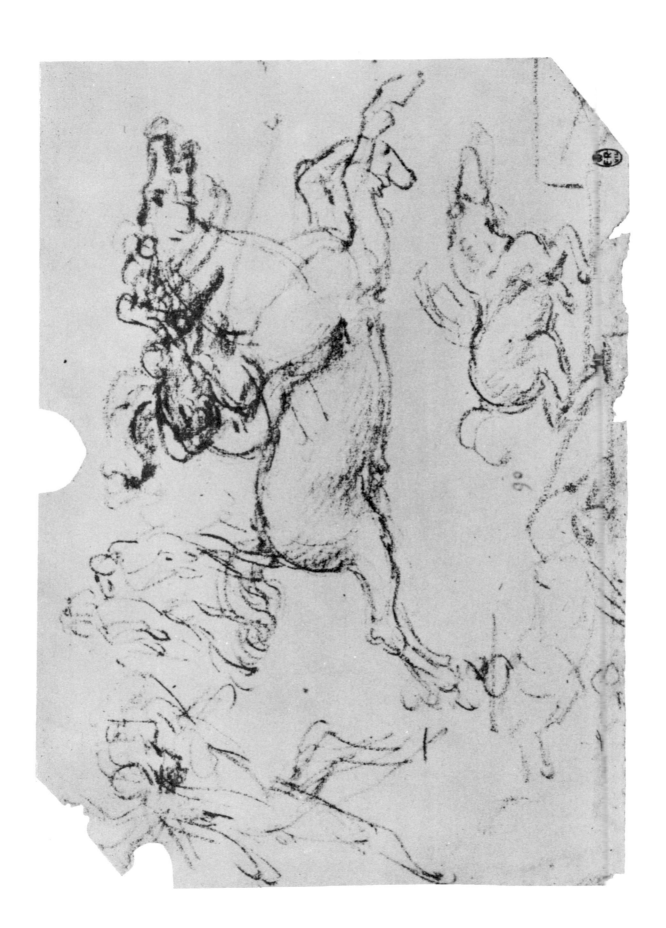

44. Probably a sketch for *The Battle of Anghiari.* Ca. 1503. Sanguine. Royal Library, Windsor Castle.

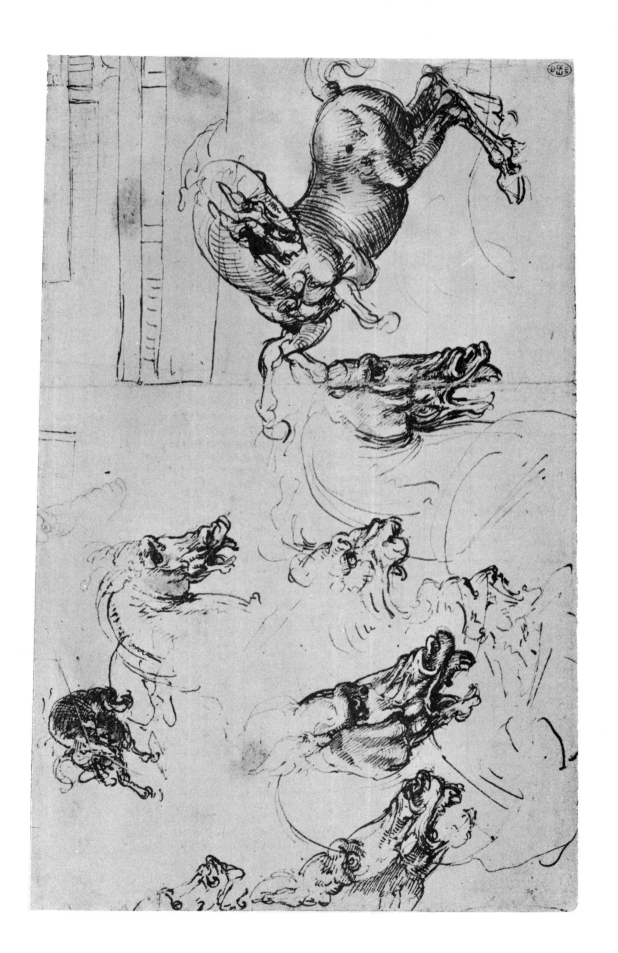

45. Probably studies for *The Battle of Anghiari*. Ca. 1503. Pen, with a few brushstrokes. Royal Library, Windsor Castle.

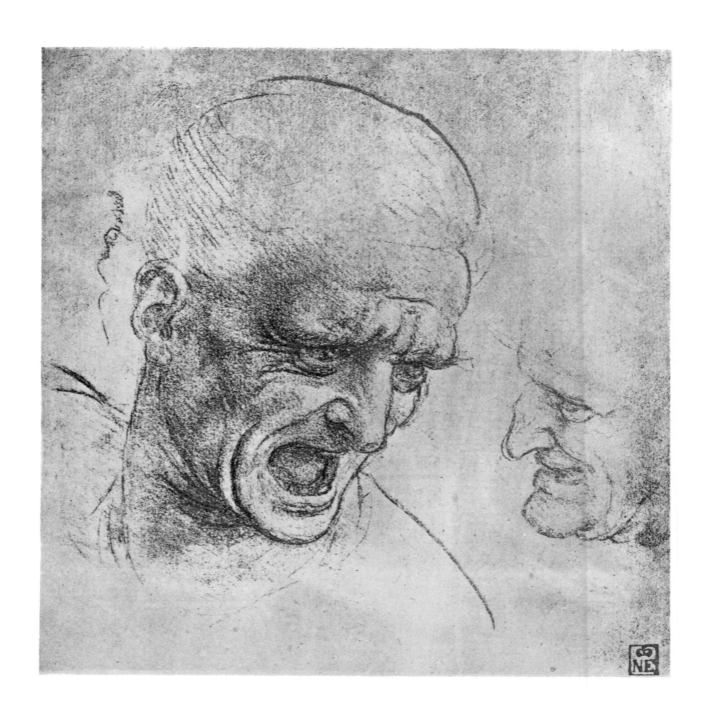

46. Studies for the two central figures in *The Battle of Anghiari*. 1503–04. Black crayon and sanguine. 185 x 180 mm. Budapest, Museum of Fine Arts.

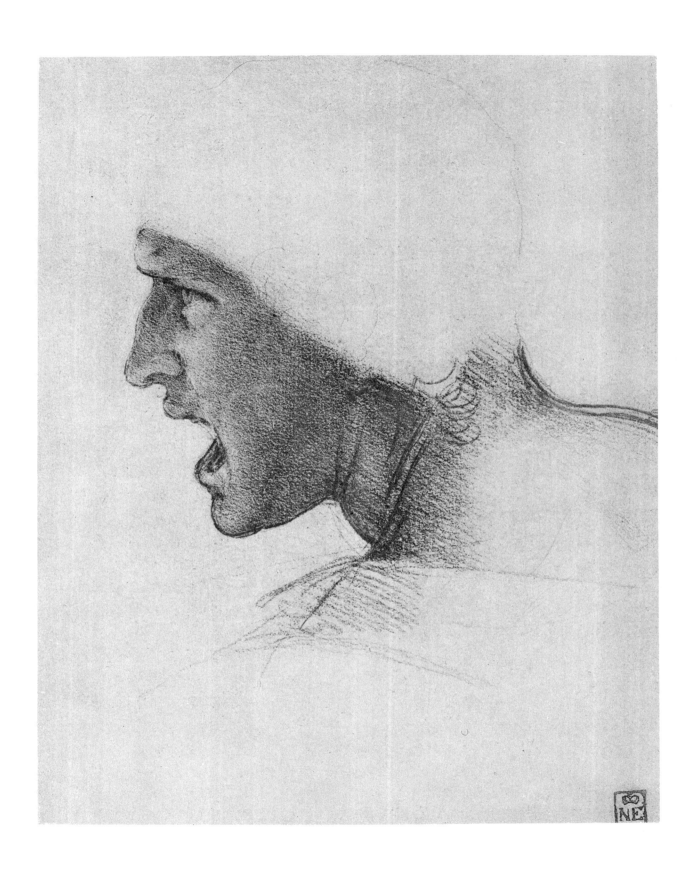

47. Study for *The Battle of Anghiari*. 1503–04. Sanguine. 210 x 175 mm. Budapest, Museum of Fine Arts.

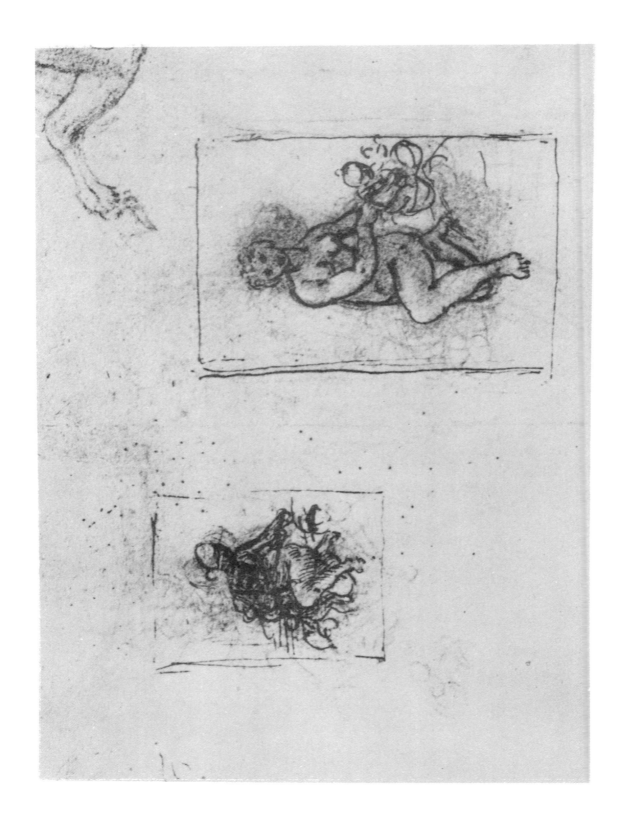

40. Sketches for a Leda and the Swan, and study of a horse. Done in the artist's last years. Black crayon and pen. 405 x 258 mm. Royal Library, Windsor Castle.

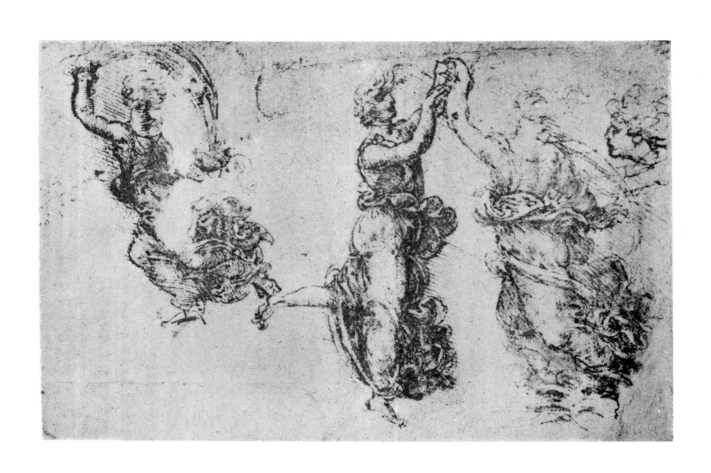

49. Female figures dancing. 1504–08. Pen. 110 x 165 mm. Venice, Accademia.

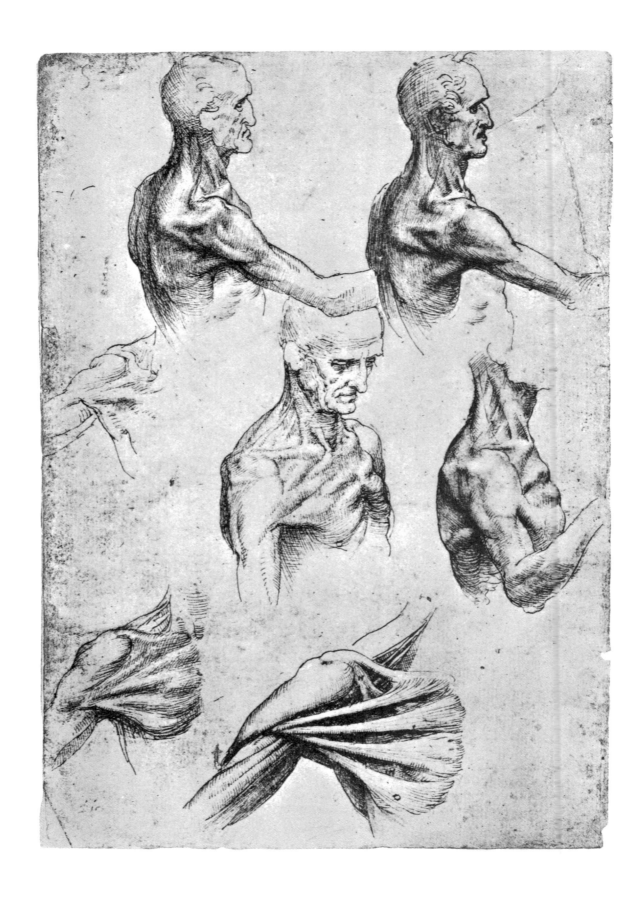

50. Studies of shoulder and chest muscles. 1510. Pen, washed with india ink. Royal
Library, Windsor Castle.

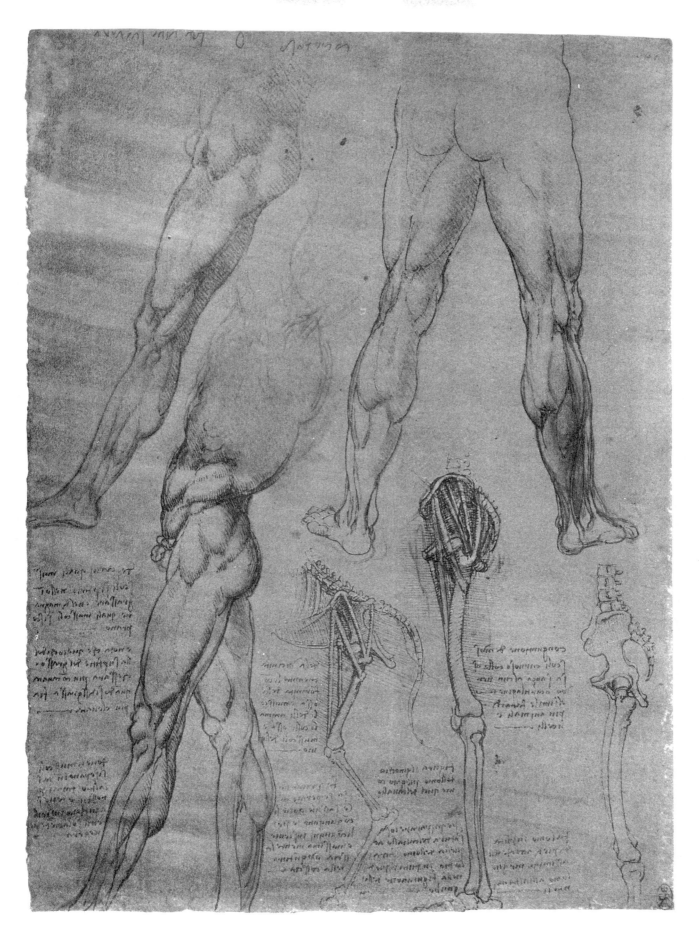

51. Comparative anatomy of human and animal legs. Ca. 1510. Pen and sanguine on brownish red paper. 295 x 250 mm. Royal Library, Windsor Castle.

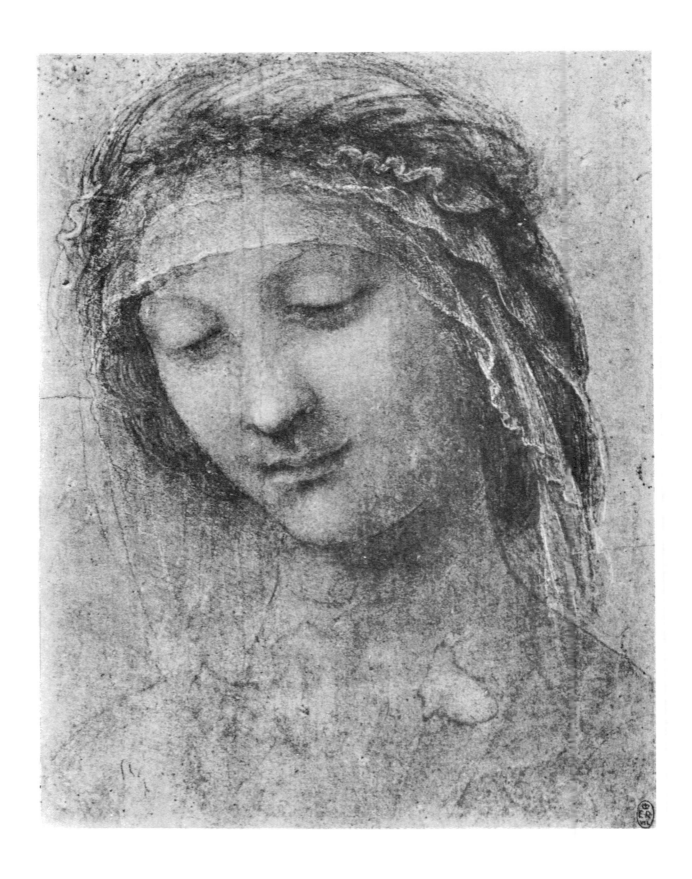

52. Feminine headdress; this has been associated with the head of St. Anne in *The Ma-
donna with St. Anne.* Ca. 1500. Pencil, heightened with white; the veil blue; on red-
tinted paper. Royal Library, Windsor Castle.

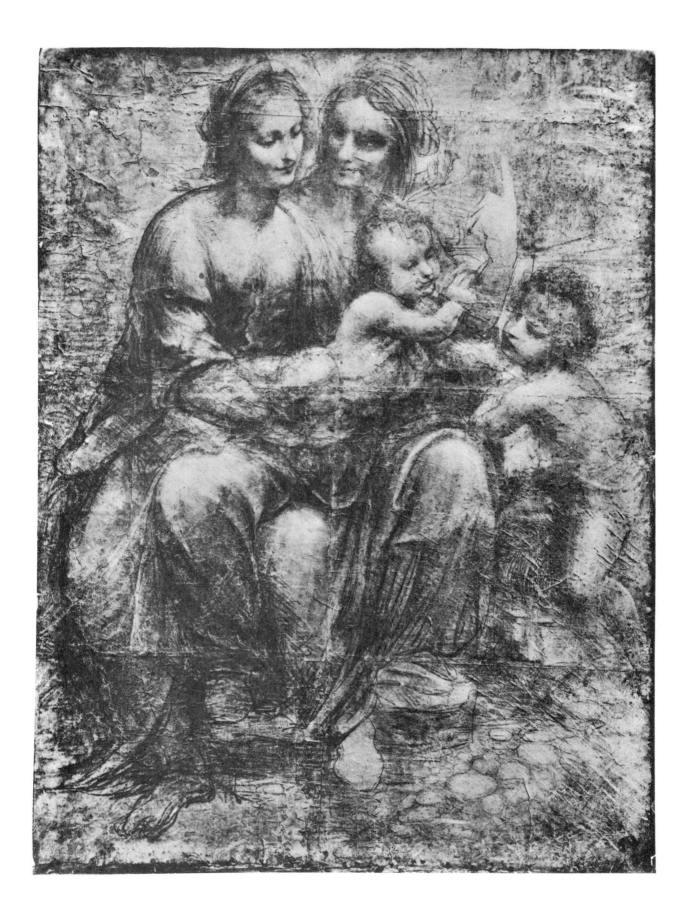

53. Early cartoon for *The Madonna with St. Anne.* Ca. 1500. Black crayon, heightened with white. 1.39 x 1.01 meters. London, National Gallery.

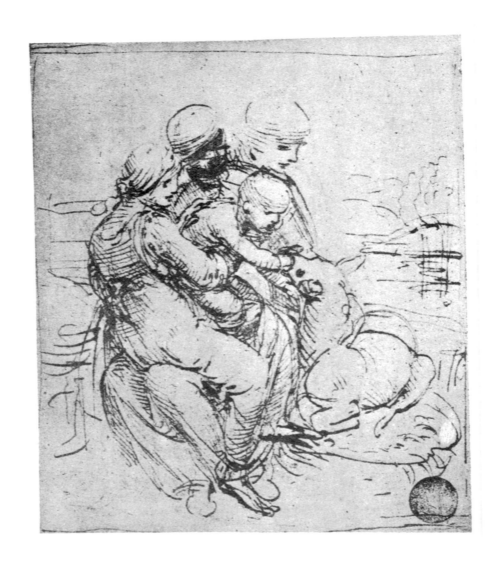

54. Sketch for *The Madonna with St. Anne*. Ca. 1500. Pen. 135 x 115 mm. Venice, Accademia.

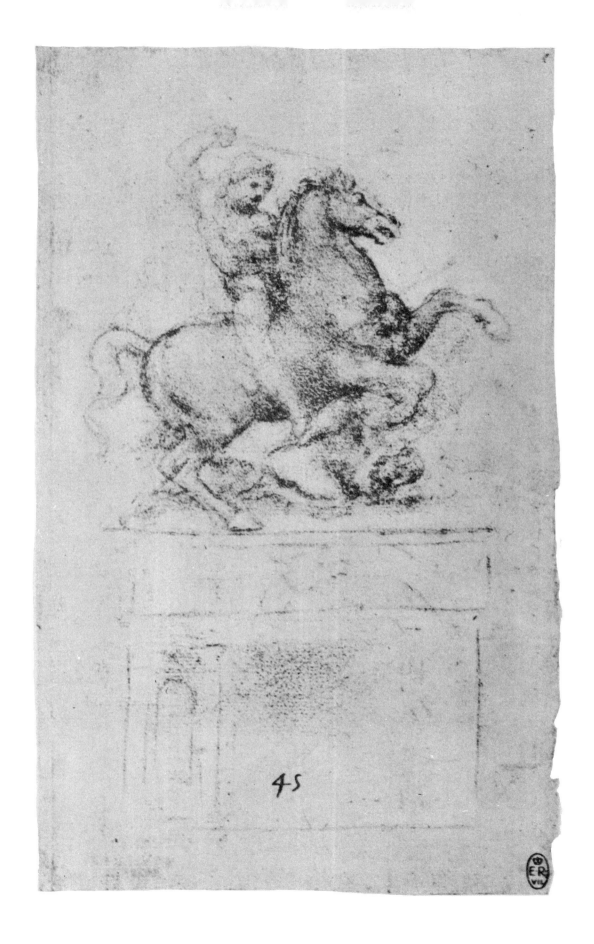

55. Study for the monument to Marshal Trivulzio. Ca. 1510. Black crayon on a pale pink
ground. 200 x 120 mm. Royal Library, Windsor Castle.

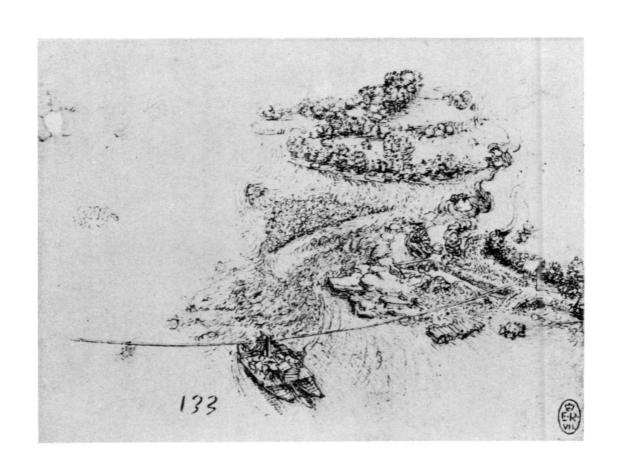

56. Rope-drawn ferry. Probably ca. 1510. Pen. Royal Library, Windsor Castle.

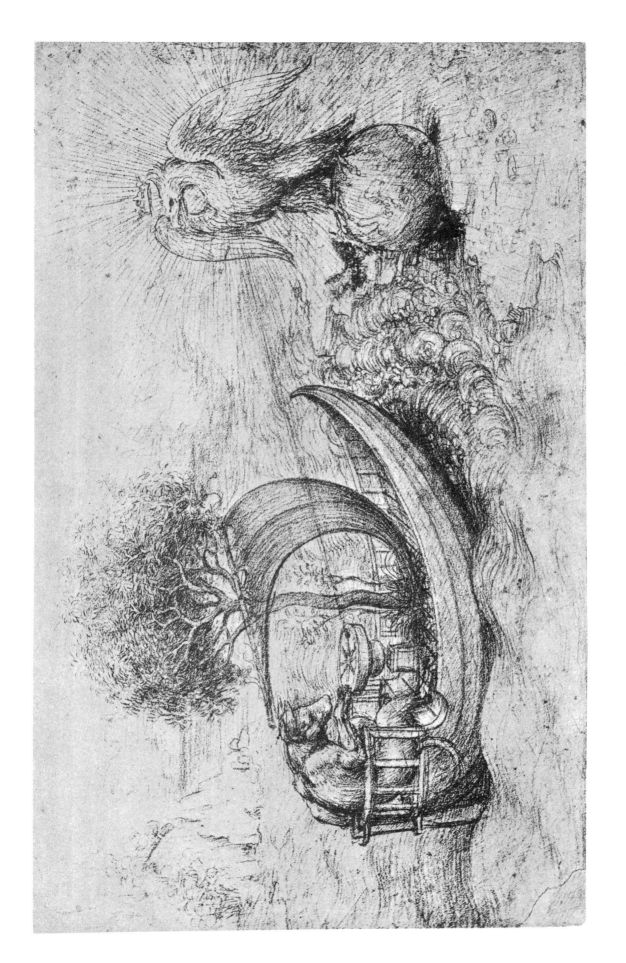

57. Allegory; this has been explained as a vision of Church and Empire, and has also been associated with the marriage of Giuliano de' Medici (the Duke of Nemours) and Philiberta of Savoy. Ca. 1500–10. Sanguine on brownish gray paper. Royal Library, Windsor Castle.

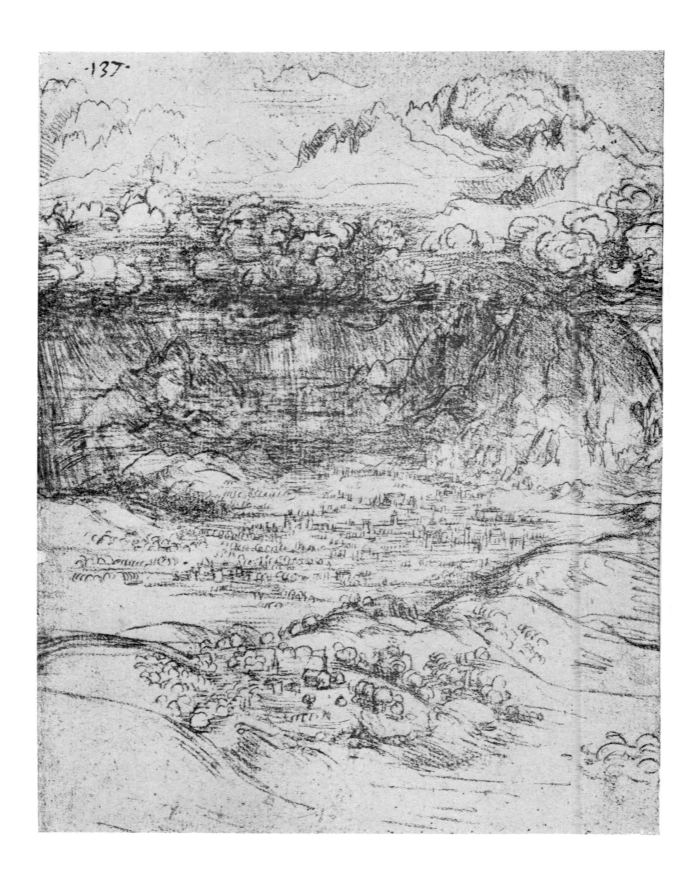

58. Storm over a mountain village. Ca. 1500–10. Sanguine. Royal Library, Windsor Castle.

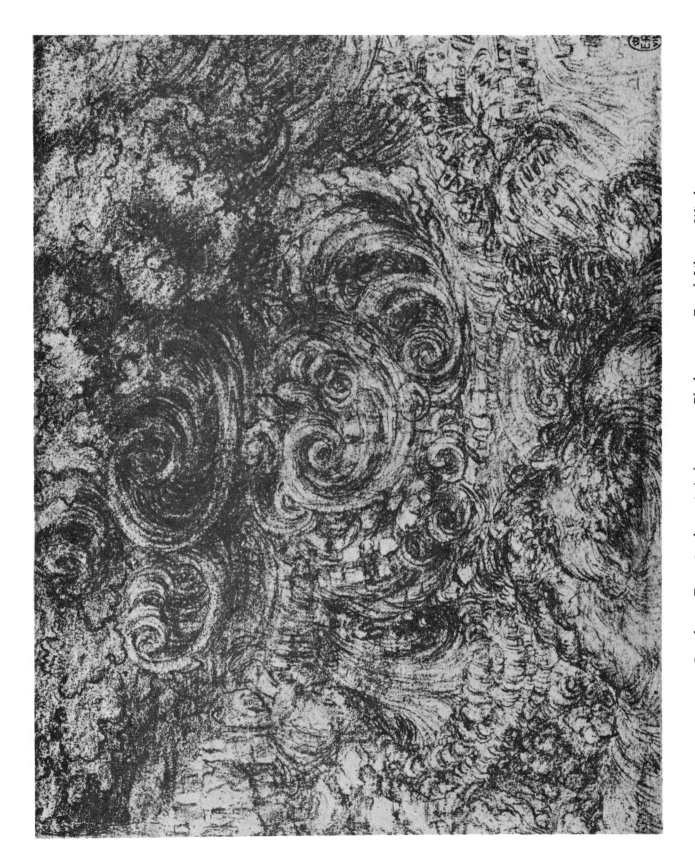

59. Cataclysm. Done in the artist's last years. Black crayon. Royal Library, *Windsor Castle.*